T0150464

MARJAN DOOM
THE MUSEUM
OF DOUBT

D/2020/45/435 – ISBN 978 94 014 7180 0 – NUR 740
Cover design: Studio Lannoo
Graphic design inside pages: Studio Lannoo
Typesetting inside pages: Studio Lannoo
Illustrations: Pieter Willems

Academia Press
Coupure Rechts 88
9000 Ghent – Belgium
www.academiapress.be

CHARACTERS

Pocket-sized philosophy and literature

MARJAN DOOM
THE MUSEUM
OF DOUBT
A modest manifesto by
a science curator

ACADEMIA
PRESS

In and out of the coach: busloads of Asian tourists stumble through Flanders, blindly following the tour guide's flag. Visiting one highlight after another in search of superlatives in grandeur and uniqueness. Stuffed with French fries and mayonnaise, chocolate, and perhaps a special beer as well. Well, clichés aside, they must have been greatly surprised when in 2017 their cameras suddenly captured something quite different from a masterpiece by the Van Eyck brothers in the cloister of Ghent's majestic St Bavo's Cathedral. They were more than a little amazed by the confrontation with a whale skeleton, or, rather, the skeleton of a fin whale called Leo.

One year earlier, on the occasion of its 200th anniversary, the University of Ghent had appointed me as curator with the task of establishing a dialogue between its academic heritage and the urban fabric of which it is such an integral part. The University literally wanted to engage with the outside world and was looking for places to do so for a year within the dense cultural network of Ghent. Cultural institutes, including St Bavo's Cathedral, were approached with the request to provide accommodation. After a few introductory conversations with Canon Ludo Collin, in which I tentatively suggested placing a showcase with a number of items of memorabilia from the University's collections in one corner of the cathedral, we both felt that a larger and more grandi-

ose intervention would not be too high an ambition. And thus, a few months later, Leo's skeleton was ceremoniously brought in, in pieces.

As a morphologist and veterinarian, I had myself supervised the autopsy and salvaging of the animal in 2015. At the time I had not yet begun writing my thesis. Leo was the third large cetacean I had worked on but still I was overwhelmed by his impressive body. It's always an astonishing experience, meeting an animal that seems to come from some fantasy world. The more so because this particular whale arrived in Ghent harbour, literally at my back door. One may have performed hundreds of dissections on animals and been through the rites of passage a long time ago, but taking a knife to and cutting open the skin of such a magnificent creature causes a feeling that is somewhat unreal. A feeling of guilt may come over you, even as a scientist whose task it is to collect data in the 'bigger scheme of things'.

A feeling of powerlessness perhaps best describes the emotion evoked by the beaching of these giants. It is an all too human response that perhaps originates in vague recollections from our collective memory: until well into the Middle Ages the beaching of whales was seen as a bad omen. Beached whales were regarded as a display of the devil and the harbingers of disaster and evil. They represented 'the other'. Whale bones were sometimes

kept in churches in the Middle Ages. Hanging these bones in a religious context provided a reminder, and indirectly a warning, of the presence of evil in this world. The whale skeleton thus acquired an almost moralising function.

It would be naïve to regard these thought patterns as no more than residues of the past. Even today, events for which we have no ready-made explanation or that are hard to grasp lead to frustration that may express itself in negative reflections. Today still, the beaching of a whale causes awe and bewilderment. In our human minds, such phenomenal animals cannot beach 'just like that.' The mere fact that we feel the need to name the animal (usually after that day's saint) is an indication of our personal bond and feeling of responsibility. Global warming, sonar, and other human influences are often pointed out as the immediate culprits. If the 'expert' on the scene cannot immediately provide an explanation for this 'injustice', people quickly come up with one even before the autopsy has taken place. Researchers have a hard time convincing people that there is such a thing as coincidence and destiny and that animals also become sick from natural causes and grow old, causing them to weaken and end up on the beach. Or, as in the case of this young fin whale Leo, that the animal was hit and mortally wounded by a freighter. Imagine if, the

day before, the nuclear power plant in Doel had been shut down because of some technical malfunction: the prophets of doom would most probably have had a field day with that.

The urge to jump to conclusions and premature explanations is all too human and researchers are not completely immune to it either. Still, it is their responsibility to collect data and then articulate plausible hypotheses and communicate these in all their nuances and even doubts, regardless of and even against thinking of the intuitive kind. Even more so: science must provide researchers with the right instruments to prevent them from succumbing to the pitfalls of their own rationality. Seeing such a body at one's feet, revealing a large, gaping wound, can even lead seasoned scientists to spontaneously ascribe the cause of death to the obvious trauma, even though the wound may well have been inflicted post-mortem. Researchers have to fight continuously against taking their own intuition for granted. This makes a whale skeleton such as this a very suitable visual model through which visitors can experience the scientific process and the necessity of scientific methods; through which they can feel this personally.

Due to its success, Leo's stay in the cathedral was extended and eventually lasted a whole year. I stopped by regularly to observe the visitors. Their response was varied and wide-ranging, as were the messages I received. I saw excited schoolchildren stare and point in amazement, I saw numerous photographers with tripods and a whole arsenal of lenses walk and sit underneath the whale, observing and discussing its details. One could almost say: doing empirical research. I was thanked in letters, in emails, and in person for providing amazement, but I was also accused of blasphemy. This diversity of response and the controversy this installation triggered confirmed my conviction that the idea had been a success.

The installation was part of my exercise to find ways to experience science and translate scientific thinking into the context of an exhibition. I had first begun this thought exercise when Ghent University had decided to give access to its academic collections in a new public museum. The University took the brave decision to invest in managing its academic heritage and to build a space where this heritage could be shared with the public. The question that immediately followed from this was what story are these objects supposed to tell? What identity should this museum adopt and where should It position itself vis-a-vis both the research community

and the society in which it resides? What role in society should it fulfil?

The following is my personal response to this thought exercise. What unique position can a museum take in the landscape of science and the communication around knowledge production, and how can it do so? Why is it so important today, in 2020, with populism on the rise, that we as a science museum provide this content here, at the interface of culture and science? In a world where the answers to complex issues have to be given swiftly and straightforwardly without the possibility of review or testing, critical thinking is under pressure. In my opinion this is a poison that is not to be underestimated and which is sneaking into our brains and into society. An important mission of science museums should lie in opening up the scientific attitude. Together with its community, a museum should communicate why nuance, self-reflection, and doubt are not weaknesses but absolute strengths in the process of knowledge creation. This is the role that we as a science museum must claim. The thought exercise became a manifesto, a declaration of principle in progress, as this exercise is never finished but is always open-ended. I leave it open in order to be able to revise it, as an ongoing experiment. Unsurprisingly, my passion for integrating art and science turns out to be

a leitmotiv that is implicitly and explicitly present in this manifesto.

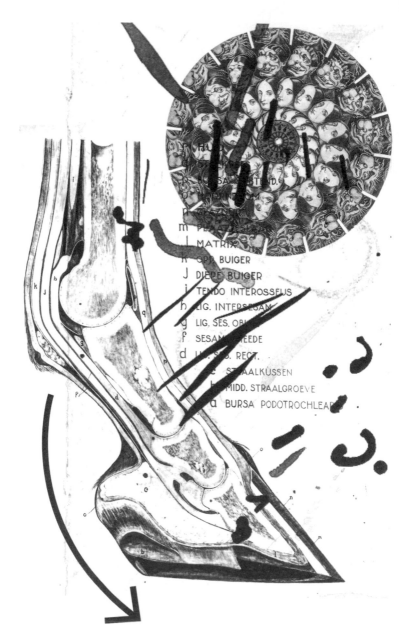

r HO...
...SAM. TEND. ...
o ...HORIZ. CM.
n GRAZN...
m PLAATSE...
l MATRIX
k OPP. BUIGER
j DIEPE BUIGER
i TENDO INTEROSSEUS
h LIG. INTERSESAM.
g LIG. SES. OBL...
f SESAM... HEEDE
d LIG. SES. RECT.
c STRAALKUSSEN
b MIDD. STRAALGROEVE
a BURSA PODOTROCHLEAR...

1. Dare to be vulnerable

Producers of culture are sometimes tasked with evoking amazement, with enchanting and stimulating the individual and collective human mind. Evoking amazement is no simple matter these days. It can take dragging a whale into a cathedral. If the focus is not on the educational aspect of science museums, the enchanting nature of the collection is often pointed out. It is true that collections that evoke curiosity and amazement are ideal for drawing an audience. They are not called cabinets of curiosities or *Wunderkammer* for nothing. Such collections reflect mankind's curious and explorative nature, the urge to collect and thereby grasp the world, and the search for knowledge. Personally, I'm not entirely convinced about communicating amazement as the sole and primordial motivation of mankind for practising science. Nor do I think much of the idea of exploiting these wonders to make converts for science. Okay, we are all of us looking for enchantment, some of us even for that one miracle that will bring meaning. The search itself, and especially the idea that the ultimate key to solve all problems can be found, is comforting in the unbearable lightness of being. We continue to fight against day-to-day worries, hoping to find some solace and resignation in a moment of happiness caused by love, friendship,

entertainment, sport, beauty, culture, or whatever it may be. Well, I guess this search is universal and common to all ages, that it is in fact a very human effort.

Agreed, gaining insight and knowledge can definitely bring bliss. To my mind, however, this represents only part of the truth. It would do truth an injustice to ascribe our drive for scientific knowledge unequivocally to the quest for the intangible, to our curious human nature that leads us from one miracle to the next without ever being satisfied. In reality, the financing of research is subject to and driven by economic and geopolitical motivation. Which is problematic, but we must have the courage to say it and not conceal it from a wider audience. In that sense, the idea of wonder as the driving force for creating knowledge confirms a distorted and romanticised image of science and a problematic view of scientists. This notion, I think, starts from a defensive attitude, from a thought that in some way or other we have to gloss over the fact that we are practising science. To my taste, it reeks too much of representing science as a practice from the latest Pixar movie to make converts and convince policymakers to invest. Perhaps my main problem is with the word 'wonder': I associate it with woolliness, which tends to make me suspicious. I immediately start looking for the sales trick. I prefer the – admittedly less sexy – word 'contemplation' or 'doubt'

as a common engine of the mind of both scientists and artists.

Perhaps I am overstating this. It is true that scientific thinking has been under fire ever since it emerged during the scientific revolution. In our present day and age, rejecting it has even taken on a political dimension. We have to defend scientific thinking with everything we've got, if we are to gain progressive insights that are based on fact. This leads to tension between, on the one hand, increasingly specialised and difficult to interpret research (and its results) and, on the other hand, the involvement of all whom it concerns (i.e. the world population). The solution is not to practise science in an ivory tower without society participating and then only talk about the success stories. That is something we all agree upon by now. But the question how then to communicate science and its methods of knowledge creation is posing quite a few big challenges. It is, after all, a hard to pinpoint concept, a way of thinking that goes against our human intuition and confronts us with our fallible brain. That last aspect we find especially difficult to stomach. It implies that we should accept that by nature we are less capable of seeing the forest for the trees than our ego will have us believe. Nobel Prize winner Daniel Kahneman expressed it as follows in his acclaimed book *Thinking Fast and Slow*:

Our comforting conviction that the world makes sense
rests on a secure foundation: our almost unlimited ability
to ignore our ignorance.

Is the solution, then, perhaps just to reduce everything
to the level of 'Einstein for dummies', carefully removing
all obstacles? No, that would be too much like Barnum
advertising: covering everything in a thick layer of sug-
ary frosting to make it more palatable. It debases science
and conceals precisely the thing that makes science so
wonderful and fascinating. Science is a human-made
way of thinking aimed at gathering knowledge as reliably
as we can. It has given us insights that, yes, have some-
times made us wonder and sometimes given us some
hold on the complex and chaotic reality surrounding us.
But it is and remains a human endeavour that is subject
to failure, conflict, abuse, and so on. And this makes it
vulnerable. However, trying to conceal this vulnerability
in order to convince and recruit is wrong, in my opinion.
The political left in Europe hasn't had much success ei-
ther in elections in the past few decades with selling a
complex reality of globalisation and multicultural so-
cieties as an effortless and quick win-win for everybody.

Of course, there is an essential difference between
political and scientific strategies. What I'm comparing is
how a complex reality is communicated to an electorate,

literally or figuratively. Dare we open up the vulnerability and humanity of the scientific practice? Or, in doing so, are we risking losing potential supporters, in these fragile times when people hunger for absolute truths? It is this fear that lies at the heart of the resistance against opening up vulnerability and science. But it is a fear that is based on intuition and therefore it should not be heeded by scientists. There's nothing wrong with vulnerability. On the contrary, there is much beauty in it as well. As a curator of science exhibitions, I wish to advocate showing the struggle between human intuition and research and to dare to communicate the failure of scientists and the reality of funding. It can only make science more human and more accessible.

132 133 134 135

2. Don't just give answers, provoke questions

Science and science museums are often criticised for disenchanting things, for dismantling magic and revealing it. As a curator I wondered whether there is an essential difference between science museums and art museums in how visitors are being challenged. Do their publics have different expectations? And is what we aim for, then, as museum workers actually different?

One of people's most important motivations for going to a museum is that they wish to learn something. Museums are regarded as one of the most reliable sources of information. This puts a heavy burden of responsibility on the shoulders of exhibition makers. Transferring information is indisputably one of the core tasks of museums. But how to accomplish this in such a way that people will remember the information, and are deeply touched by it? I love museums, am a real glutton when it comes to visiting exhibitions, and I'm not particularly discerning. I do look for information – preferably mind enriching – but mainly I visit an exhibition to be moved. In the same way that after seeing a powerful play or a touching movie, or hearing a compelling concert, I can still be ruminating about the experience days later. When I feel I have to process the experience and

feel the urge to share it with friends, my visit to an exhibition is a success.

The ways in which art museums try to accomplish this compared to science museums are quite different. The first are traditionally part of the cultural domain, the second are more in the field of education, science, and innovation. Many museums of natural history and other science museums focus on interpretation. Paradigms are being historically framed and theoretically underpinned. And ideally there are hands-on activities to make visitors experience the natural phenomenon themselves. And, as the cherry on the pie, it should preferably be enjoyable, in support of the science-is-fun concept. And so, the visitor's learning process is neatly grounded in science and all educational profiles are nicely addressed. There's nothing wrong with this per se, but where does the stimulation of reflection come into play? Should the information provided be this manageable and easily digestible, or should we rather plant seeds for the visitors to work with themselves?

The museum as a place for the passive transfer of knowledge is a thing of the past, anyway. Charles Leadbeater, a member of Demos, a London-based think tank for the development of 'evidence-based societal solutions', put it like this:

> A museum exhibition is not simply the result of self-
> expression by the curatorial team of a preconceived
> idea ... The museum's role is not to proclaim but to
> listen, interpret, incorporate ideas and adjust ... For the
> museum, an exhibition becomes more valuable the more
> it encourages people to join dialogue around it and to
> construct new meanings among themselves.

Somehow, this notion seems to have dawned on art museums more than on science museums.

Art can be an instrument that encourages us to reflect on things. This makes it a necessary part of a free society. In places where art and the imagination cannot or are not allowed to fulfil this role, free thought is restricted. Art can stimulate individual critical thinking. It can force us to take our time to apply our own thought processes to issues we encounter and that take place around us. This encouragement to think outside-the-box is for me a crucial part of training one's own response and opinion in order to avoid blindly accepting some truth. It leads to an enrichment of one's own and the collective human spirit. It can be the starting point for exploring alternative ideas and critical citizenship. In art museums we expect to be challenged. Why, then, should a science museum restrict itself to the passive transfer of information? Science – pre-eminently the discipline that poses

questions, that interrogates, that keeps questioning. Why shouldn't we as science museums be allowed to envision the same goals for our visitors?

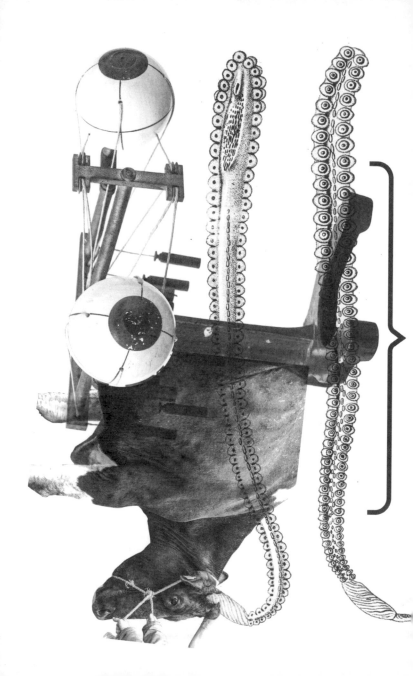

3. Focus on the process, not just on the result

Exhibition makers have a strong inclination to high-light mankind's accomplishments, with a preference for triumphs. The appeal of heroes and their stories is ingrained in our genes. Marvel built its comic-book universe and business empire on this longing for heroic acts. The road leading to heroic success is something we often find less fascinating, somehow. Especially when the journey has not ended in an arrival in Walhalla, but has stalled somewhere along the way because of human or other failure. Struggling in itself may be captivating, especially when the underdog is triumphant in the end, but struggling that leads nowhere is not very appealing. However, in my opinion, museums that only provide a platform for the hall of fame of mankind put the societal role of museums up for debate. This reminds me of the book *The Museum of Innocence* by Turkish Nobel Prize for Literature laureate Orhan Pamuk. In it, he advocates a museum collection as a set of objects that reconstruct our daily lives through stories. He argues against museums that administer collections of objects that are supposed to represent the grandeur of heroic acts and other superhuman accomplishments. Pamuk's manifesto is a specific indictment against museums being instrumentalised to whip up nationalistic sentiments. He cham-

pions a museum that connects, that does not deepen or painfully reveal the gap between us all or between groups of which we are either or not a part. The museum as a public place for an open dialogue. We don't necessarily have to agree with each other. We may and should debate, but the starting point is still what universally binds us as undistinguished human beings.

In science museums, and in science communication in general (in any form), this pitfall is often not avoided. We place the results in the spotlight and the more spectacular they are, the better. The 'translation' for the public basically comes down to converting scientific language into an understandable and appealing vocabulary about the achieved scientific goal. The road leading up to that result, the process, is not mentioned. How and why a researcher arrived at his or her question, how much failure was involved, that in fact this one researcher stands for a whole group of scientists behind this result, let alone that the result is being contested and questioned by other research groups, is mentioned only in a footnote, with any luck. Although all these elements are essential parts of scientific practice, it would make the story too complicated. In addition, the public, having often funded the research as taxpayers, should in the first place be able to see where all this researching and thinking can lead. This is often the argument given, but I believe that this

is a rather patronising attitude. It doubts the intellectual ability of the public and does not examine the field of interest, but imposes it. Moreover, it creates an image of science as a superhuman activity, bestowed only on brilliant loners.

Be wary of dogmatism. By communicating only half the story, i.e. the result, and leaving out the doubts, we lapse into exactly the thing that we as a scientific community are trying to fight. The story, the experiment, doesn't have to be completed before it is presented to the public. Artists in particular present a thought process rather than a solution to a problem. Looking at a work by Rothko together can be an intense and binding experience. And, although it may seem less obvious to many, looking at a Foucault pendulum together can be so too! That experience also contains a potential range of existential questions. It is a matter of how it is exhibited and to which end.

I am convinced that entering into a dialogue between science and art will stimulate the science community to embrace its role more fully as a societal think tank. The funding model for scientific research, in its extreme form, seems increasingly to reduce the role scientists are allowed to play today to that of generators of quantifiable knowledge, preferably with quick economic valorisation. We seem to accept more readily artists holding up a

mirror to society. The cross-pollination between both is a catalyst for the role of scientists as the embodiment of critical citizenship. It may encourage them more openly to adopt this role, which they sometimes seem to have forgotten under the pressure of lack of time. It is a role they can inhabit in full in the safe, supportive refuge of a cultural home like a museum.

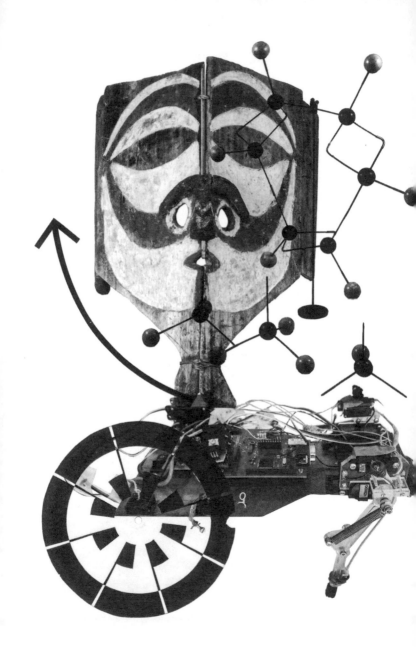

4. Also think ex situ

It was no coincidence that I placed Leo's skeleton outside his expected habitat, in a religious context. Religious, in the sense of how that other Leo – the Ghent philosopher and advocate of atheist spirituality whose surname, as it happens, was Apostel – approaches the phenomenon. This immediately implies that researchers do not decry emotion, while upholding scientific standards. Walking into the cathedral, one has an overwhelming experience of spirituality, regardless of whether this is linked to a personal religious belief. Voices are lowered, steps are taken more slowly, the gaze wanders. I experience a feeling of bonding with the people who are around me at that moment, but also with the people who wandered here before me; it's a connection with mankind in general. The mind is open to visual stimuli, but all other senses are involved as well. This is why I still know – by having spent much time here while preparing for the exhibition of Leo – exactly how the sun makes its way around the cathedral during the day, through which stained glass window it shines on any given moment, which places feel coldest because of the thick insulating construction, how the apse chapels smell, and what sounds visitors' footwear makes on the magnificent floor tiles. Here, information is stored in deeper layers, as is the informa-

tion content connected to it. In all, a gratifying place for a curator.

And so Leo was put on display in the cathedral, without an object label saying *Balaenoptera physalus spp.*, but precisely in the spot where the sunlight entered beautifully in the afternoon, almost sacralising him. The skeleton was not even accompanied by a map of his natural habitat and feeding grounds. Instead he was accompanied by a poem written for the occasion by Peter Verhelst, using the emotional experience of beholding a whale as a metaphor for the untameable longing of mankind for the unknown. It is a poetic encouragement to not look passively but to actively explore what you see and experience. It catalyses the fear of the unknown and the appeal of the grandiose. The overwhelming location, full of the history of human rituals, confronts us with our need for a grip, our tendency to want to see and make connections, even on the basis of doubtful arguments. The tools that science provides us with to engage in the creation of objective knowledge should safeguard us against the derailment of thought. It is important to keep in mind that in science also the so-called regularities are, after all, human constructs susceptible to revision and even falsification. The belief in the infallibility of scientific data is best put in parentheses. Doubt remains our guiding star. At least, that is my hypothesis. And although

I haven't collected any data, for example by interviewing visitors about their experience, my observations lead me to intuitively conclude that the experiment is in any case partly successful in planting a bit of healthy and stimulating confusion in the minds of the visitors.

The context and place of this exhibition provide an extra layer of meaning. A *lieu de mémoire*, a memory space, can be the agent that binds the scientific content of an exhibition to an experience. Scientific institutions have so many occasions to create windows of opportunity in the ivory tower. A museum, which should by definition be part of the public space, is the perfect catalyst for really opening up the tower.

In 2015, together with visual artists Chantal and Pascale Pollier, I curated the exhibition 'PostMortem', in which Ghent University arranged a dialogue between museum collections and the work of contemporary artists. On the one hand, the exhibition showed the scientific process within the discipline of anatomy, while on the other hand its intention was just as much to have visitors experience science as a human process and encourage reflection on science and ethics. As the GUM (Ghent University Museum) we do, after all, wish to provoke critical thinking in visitors, rather than simply be a platform for the illustration of research results and information transfer. The exhibition took place at the wonderful

neo-Gothic Rommelaere Institute, designed by the architect Louis Cloquet (1899), in the rooms where, until just before the opening, the Forensic Medicine Department of the University had its base. Our exhibits were in the library, the offices, but also in the cold storage spaces and the rooms where post-mortems were performed.

The authenticity of these rooms enhanced the visitor experience, although there was a risk that they could be overwhelming, thereby hindering the reflective attitude we aimed to evoke. The contemporary artistic work in the clinical spaces made the confrontation with the harsh theme all the more tangible. It made the visitors more aware of the fact that scientists too are confronted with ethical limits and with emotions that can be blinding. Researchers handling a dead body, making it undergo the transition to an object of study, of course also ask themselves questions about mortality and are struggling just as much not to be overcome by atmosphere and emotion. For this exhibition, photographer Johan Jacobs invited dancer Dirk Hendrix to lie on the post-mortem table. I will spare you the experience of the production process in the abandoned, dark post-mortem room, but the visual experience of the on-site installation was just as intense and confrontational: in an animation, visitors saw the life-size image of Dirk's naked body on the cold table. The same table that was still there, just a few metres

to the side. The body remains motionless for a long time, until, with spasmodic, crescendo movements of breathing, the image begins to move. The body is struggling in an attempt to free itself from the table, to ascend and look down upon itself.

Providing a personal, recognisable experience through artistic means enhances the visitors' involvement and their readiness to explore the theme in more depth. The artist leaves the interpretation to the beholders, giving them more freedom in this regard and facilitating a debate. This experience is much harder to accomplish by exhibiting scientific instruments and providing the translation of research results in museum language. Also, art has the ability to touch upon things that are universal and timeless, things that bind us as humans, and so enables visitors to share experiences.

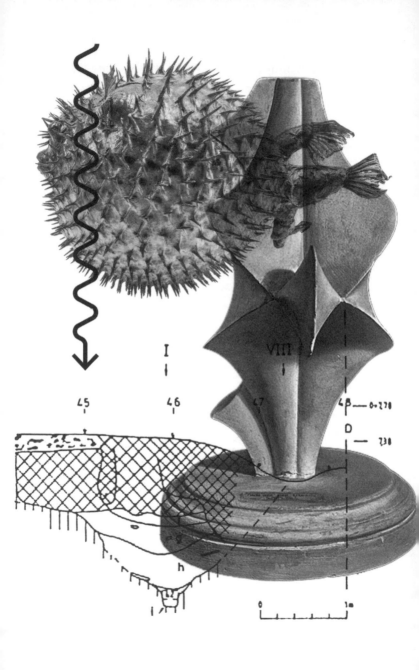

45 46 I VIII 47 48 — 0·270

D — 230

0 10

5. Dare to make exhibitions interdisciplinary

Traditionally, museums of natural history and science organise exhibitions neatly by discipline. Rooms called 'Theory of Evolution' or 'The Body' are well-established and recurring themes, for example. It relegates many science museums to the status of carbon copies of the same thing over and over again. The potential to create surprise is small, as visitors are being served with what they expect, resulting in a rather passive transfer of knowledge. Alternatively, exhibiting objects that represent different disciplines side-by-side is more likely to stimulate visitors and encourage personal reflection. Juxtaposing things that at first glance are completely unrelated has the effect of surprise. Visitors are more challenged to see connections, i.e. read the language of the curator, and this creates time. Time, and 'headroom', that visitors don't allocate to bite-size information transfer but that are needed for reflection.

The explorations I have undertaken in preparation for the opening of the GUM through the thousands of objects in the University's collections but also in attics, basements, hallways, and offices were a real eye-opener. This is an experience we should share with our visitors. From a Tasmanian wolf, Ngala headhunters' knives, the first Bakelite, and a scale-model of the Pantheon made of

cork to … a luminescent dress designed for Belgian singer Dana Winner. It is challenging to weave a connecting thread through the diversity that can lend a higher dimension to the opening up of this academic heritage. But it is precisely in the juxtaposition of such different objects that we find the surplus value; multitude and diversity should not lead to a lack of direction. On the contrary, they create an opportunity for confronting the stereotypical image of science as a rigid, well-delineated concept. By placing such varied objects and the ideas behind them in dialogue or opposition, one can highlight the complexity, humanity, and beauty of the practice of science.

The same object will trigger different research questions with researchers from different disciplines. It requires the efforts of the curator to weave the interdisciplinary thread through the scientific story. It requires an effort to take up the position of the meta perspective, especially for researchers who are trained to study the sub-question of a sub-question of a discipline. How, as a science communicator, does one find the right language in which to speak to a public when researchers from different scientific disciplines are already finding it difficult to talk to each other? The language and jargon that are linked to a discipline have become so specific and specialised, even to the extent that some see this as

a threat to the scientific practice itself. Already in the last century, the science historian George Sarton (1884–1956) concluded that scientists from different disciplines had become unintelligible even to each other. He therefore started looking for a common, unifying language, which he found in the language of science history. Language is an externalisation of the vocabulary linked to the frame of reference in which the mind functions. In order to guard the freedom of the mind, interdisciplinary collaboration is necessary, as advocated by the philosopher Leo Apostel (1925–1995).

As for myself, I was catapulted out of the caves of my rigid thinking by collaborating with artists. It provided me with the oxygen to take a fresh look from a bird's eye perspective at my own field of enquiry and at science in general. For me, it triggered the transition from researcher to curator.

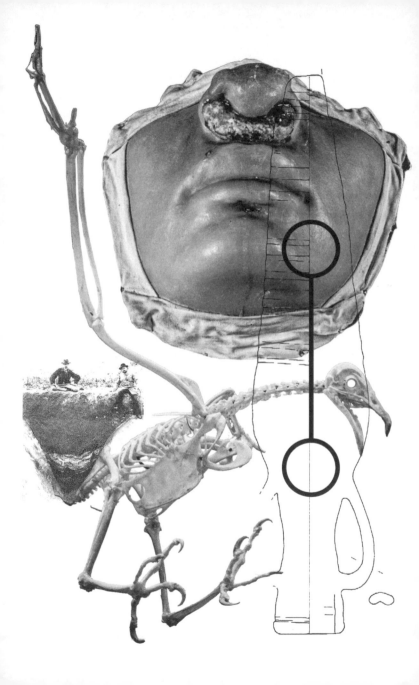

6. Find the dialogue with the arts

Some years ago, on a lovely autumn evening in Ghent, I went to see *Au Coeur Volant*, a play by Herwig De Weerdt, inspired by the meeting of Albert Einstein and James Ensor in 1933, in the restaurant of the same name in the Belgian village of De Haan. No one knows what exactly these two iconic figures discussed at the time, but it seems to have been a lively conversation and at least they agreed on the physical qualities of the waitress. On stage are a table, two chairs, a restaurant kitchen, and two diners: the scientist, played by Jean Paul Van Bendegem, and the artist, played by Kurt Defranq. The ninety-minute conversation we are witnessing is a little bit awkward. There is quite a bit of misunderstanding. The different 'dialects' they speak are not exclusively the result of a difference in trade vocabulary. One could regard the conflict between reason – inevitably ascribed to the scientist – and emotion – obviously ascribed to the artist – as the cause of the linguistic misunderstandings. That would be too simplistic. As if researchers wishing to draw conclusions from data would never let themselves be guided by emotions. As if every brushstroke is exclusively the product of emotion and never of reason. No, this clash is situated elsewhere. It is almost as if the scientist and the artist do not even expect to arrive at a com-

mon language. Both men treat each other with stereotypical bias. The scientist tries to engage the services of the artist in assisting with the organisation of a convention. A nice gesture, but as the play progresses it becomes clear that the artist is only supposed to deploy his qualities in the way of illustration: beautify the backdrop and general atmosphere of the convention, as it were.

These may seem like clichés but they are recognisable. I have the privilege of frequently moderating encounters between artists and scientists. As in *Au Coeur Volant* this often leads to quite hilarious situations without the protagonists being fully aware of it. There is much frowning and/or exchanging of looks of bewilderment. I remember a conversation between an artist and a researcher about a 'phantom mare', a dummy that stallions mount so that their sperm can be collected for artificial insemination. It is a practice that is almost the default procedure in animal breeding. The Department of Fertility Research for Large Domestic Animals at Ghent University still has a leather dummy mare that is around a hundred years old. The bite marks and other traces of the stallions that have fierily mounted it over all these years have been engraved in the leather like scars. The phantom oozes a history of aggression, virility, and sexuality. Or, at least, that is how the artist enthusiastically read the object. The researcher, by contrast, pointed out

with equal exultation the sophisticated new synthetic phantom that stood there shining next to the, in his eyes, obsolete leather dummy. The new one had been acquired with the funds for a prestigious research project, was automatically adjustable in height and size and temperature-controlled, all to accommodate the stallion's preferences. In short, it came with all the options. Nothing was really achieved by this conversation, but the artist was given access to the leather phantom mare so she could 'work' with it. Still, it is regrettable that no real mutually inspiring dialogue was initiated, not even about something as concrete as an instrument that carries both the history of a scientific discipline and bears universal traces that anyone can recognise.

This question of why it is so difficult to find the right interdisciplinary language has occupied me for some time now. All the more so because I have also experienced the incredible beauty that emerges when a common language is found.

I can precisely reconstruct when my frame of reference as a scientist was shaken up for the first time. In 2008 I began working as an assistant in morphology at the Faculty of Veterinary Medicine at Ghent University. The discipline appealed to me because it could provide me with a deeper insight into the functioning of the body, and of life. It also brought me closer to dissecting

– a skill that is embedded in a centuries-old tradition of the scientific enquiry into what makes us wonder (and this is not a sales pitch). Armed with a scalpel, the anatomist cuts manually through hypotheses. It takes a rite of passage to be able to approach and regard the body as a building plan with a pattern of structures. Or, rather, to be able to dissect it as a model in which, after some practice, a logic is to be found. A continuously deepening insight may also suddenly lead to new questions. As a researcher you then know that you're on the right track. A point of insight is reached, the eye is trained, craftsmanship is in the making. Only then does it become interesting, only then is the scientist capable of perhaps contributing a small piece of the puzzle to the already acquired knowledge in our ultimate search to understand the reality we live in.

This was, roughly speaking, the point I had reached when visual artist Berlinde De Bruyckere invited me to collaborate on an installation in the dissection rooms involving horse cadavers. In this monumental work two entwined bodies would be hoisted up by the front legs, evoking a confrontation with death and suffering but also emotions of consolation and human bonding. It was a very intense week, with much discussing, observing, sharing, and work days that lasted until the early hours. The experience prompted me to look at my own study object

with fresh eyes and find new beauty in it. For hours the two of us would look at every detail in the form. We discussed each muscle curve, evaluating the impact of each tendon or dissection of tendon on that form. It was neither a search for a system of blood vessels, nor an exploration of joint and other body cavities, but a study of the interaction between form, perception, and experience. For the first time, I felt privileged to be allowed to study the discipline of anatomy in depth.

The morphology, on which I was beginning to get a grip after all these years of study and the logic and design of which I was finally beginning to understand, now suddenly transgressed the borders of the conceptual frame I had established. It became a turning point in my own experience of science and my way of observing. It could have caused confusion, and in fact it did. But, contrary to what one might expect, it did not make me feel rudderless, but rather brought me relief. Yes, relief. Let me explain. During the training to become a scientist one acquires the view and way of thinking of the professional. These skills are required to be able to function correctly within the demarcations of scientific practice, in order to gain new knowledge in the most reliable manner. However, during that training process this view tends to develop a certain rigidity. This occurs almost unnoticed and certainly involuntarily. Flexibility of the mind and creativity are neces-

sary conditions for tackling a problem. Although they are intrinsic to and necessary for the research process, my feeling is that this openness is put under pressure during the training to become a researcher.

The dialogue with Berlinde rather abruptly confronted me with my own carefully constructed tunnel vision. Later, I learned from Professor Ann Buysse that in sociology this mechanism is referred to as 'trained incapacity'. Or, as Professor Emeritus Ronald Soetaert says:

> The way you learn to observe determines the way in which you observe. In itself there's nothing wrong with that, but it can make one blind to innovation.

And this is exactly where the danger lies. Blindness to innovation and alternative discourses can never be beneficial to the quality of research. It cannot possibly encourage out-of-the-box thinking. Also, the increasing specialisation within the sciences threatens to make the observing gaze more and more rigid. Staring into the depths hinders the broader vision.

For scientists it can only be healthy to look for interdisciplinary collaboration and the associated other ways of seeing. Not just with the neighbouring research group down the hall but with artists as well, who are especially trained to seek the confrontation with the rigidity of their

own field of vision. Disruption of our grip on the known need not be scary. On the contrary, it is an essential part of searching for advanced insight. In his formal lectures, the art historian Professor Dr Koenraad Jonckheere refers to what Leonardo da Vinci calls 'the poetic moment': the momentum where the dialogue between art and science is done most justice: the momentum following the eureka experience in research and the fleeting feeling of total understanding. This is exactly when the confrontation with the illusion of understanding presents itself. But it is also from this momentum, which scientists and artists are especially able to evoke in each other, that innovative ideas may arise. A situation of knowing and not knowing, seeing and not seeing, may not seem very appealing from the perspective of the individual researcher. From the broader perspective of the human quest it does represent a surplus value, even a necessity, I would venture. In addition, a certain beauty may be revealed to the individual researcher and it may even lead to a sense of relief, as mentioned earlier.

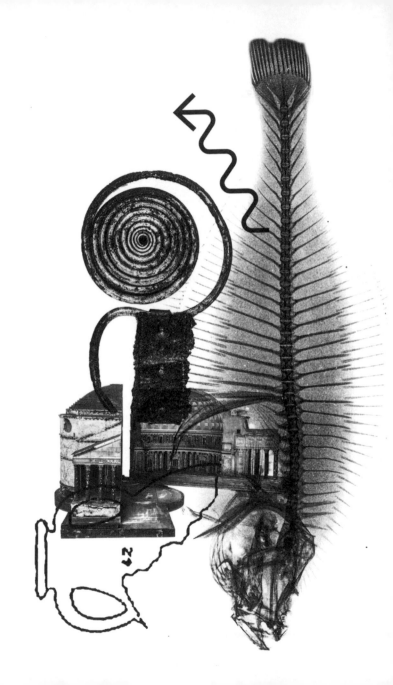

7. Don't ignore the beauty and the poetry

My first memory of visiting a museum of natural history must have been of the one in London. It was a family outing, and my parents considered a visit to this stalwart London establishment as a reward after all the art museums. And it was, even though art museums like Tate Modern equally impressed me. With scientific collections, for example of skeletons, we all too easily assume that they will provoke amazement no matter what. That children will be enthusiastic, almost regardless of how the collection is presented. With art, there is more recognition of the fact that the right context should be created for observing and really taking in the work.

Browsing among my memories of any of the museums I have visited, what surfaces is their collections and the architecture in which these are housed. The building does not have to be monumental per se. The quiet, the shutting out of outside noises, and soft lighting encourage reflection. To enter a museum is for me to be present in the here and now. Museums are part of public space and their collections are part of mankind's heritage. The mood in which the collections are presented, how visitors may interact with the objects, and what kind of experience we offer them lie in the hands of the museums. For scientists, the wonder and beauty of a

collection often reside in the story that the objects can unlock, what major breakthrough they clarify, what fascinating natural phenomena they illustrate. Recognising the beauty in the stories should not, however, lead us to ignore the aesthetic value of the object and in how it is presented.

There is a curious tendency in museums of natural history: objects are increasingly moved to storage rooms to make way for multimedia applications. This underlines the idea that in our discipline we should primarily focus on interpretation and explanation. That our main goal is to transfer the story behind the object rather than to share the object itself and leave the interpretation of its meaning to the public's imagination. The information we wish to provide is extensive, but the number of square metres of space a museum has is limited. The knowledge contained within an object is multi-layered. Unlocking this knowledge on a screen in combination with an interactive application is not only an efficient way of using space; it probably triggers more learning processes than just observing the object might accomplish.

However, shifting the collection to the background negates the museum as a place where time is allowed to stand still for a moment. A place where perhaps it is not so much the quantity of knowledge gained that counts, but rather how well that knowledge is embedded; where

the way you meet challenges is permanently changed. It has not so much jostled for a moment the pillars upon which your truth rests, but rather permanently shifted a rock in your stream of thoughts. A place where social cohesion is enhanced by sharing an experience of looking and reflecting on that experience, and yes, absolutely by sharing wonder. Museums are built on the foundation of their collections. Keeping these safe and unlocking them for humanity: that is their core task. The stories told by the objects are connected to what goes on around the museum at that particular time and therefore by definition vary with the spirit of the times, with the culture in which they breathe. In the digital era, providing a digital experience that can address so many more senses and levels at the same time than a piece of text is an almost logical evolution. Tangibility apparently has become a less prominent requirement. Of course, such digital museum experiences have their rightful place and I certainly do not advocate for museums to be archaic places stubbornly holding on to the dogma of the 'good old days'. The museum sector must be in tune with the society in which it operates and partly go along with the currents that inform it. Digital developments are surely part of that, but I want to stress that we should not disavow our identity as museums-with-collections. Objects offer an experience of authenticity that is unique to the

museum context. That element of connecting people through sharing an experience must be guarded. That encounter, as well as with objects that come from the production of knowledge or the quest for it, can be an aesthetic one. There is beauty where we don't expect it and experiencing that beauty together can be incredibly powerful.

I'm thinking of the installations of filmmaker Sarah Vanagt. In her work, Sarah starts from a story from science history but she reinterprets it and transforms it into a poetic visual language that touches upon a universal experience. Or, as Da Vinci phrased it:

> Art is the queen of all sciences communicating knowledge to all the generations of the world.

In her short film *In Waking Hours* Sarah, together with historian Katrien Vanagt, reconstructs the experiments done by the anatomist Plempius (1601–1671). Plempius described how an image was constructed on the human retina, by conducting experiments on the eyes of cows. In an attempt to understand how the image was captured, he compared the eye to a camera obscura. The visual language in Sarah's award-winning short film makes the viewer experience the inquisitive nature of mankind, evoking a sense of enthusiasm and zest for science. But most of all it shares the beauty of the scientific experience.

The GUM as a case study

Obviously, the ideas, reflections, and issues mentioned above lead to the question of how the selected vision and the eventual museum display can inform and optimise each other. Putting a vision and theoretical jottings on paper is an academic's bread-and-butter but translating them into reality is quite a different challenge. In what follows I describe how, in the case of the GUM, vision was translated into practice. I still consider this setup as an experiment and, more literally, as a test. Starting from the hypothesis that vision and setup do indeed optimise each other, then this experiment can, and may, in other words correct the hypothesis or, more radically, overturn it. I don't mind that at all; on the contrary, I welcome it.

Upon entering, visitors are first treated to a film installation by, you guessed it, Sarah Vanagt. This looking beyond the horizon provides an immersive experience that breathes poetry and brings the mindset and expectations of visitors in line with what the museum is offering. If visitors were still expecting white coats or, in their mind's eye, would be tempted to lean back comfortably, ready to digest knowledge and information like popcorn, then such expectations are readily adjusted right at the start of their visit. The opening film treats them to an exploration of 'looking'. It visualises how the development

of viewing instruments such as the microscope and the telescope continuously readjust our view of the world and of ourselves. Visitors experience the 'homo ludens', the pleasure of experiment and discovery, but also the uncertainty and the questions that accompany the discovery of a new visual world. The fact that we are technically capable of going to the moon does not mean that we understand exactly what it is we are seeing there.

The exhibition covers seven themes, which do not necessarily have to be seen in a specific order. Even so, the central route that has been mapped out has some surplus value for those who like a little guidance when visiting a museum.

Let me take you on a guided tour of a curator's mind by discussing one object from each theme.

CHAOS: A map of dialects

The first theme covers the sense and nonsense of classification. The cliché has it that scientists think strictly in compartments. When they encounter a collection, their analytical mind immediately starts defining well-delineated sub-collections. They just can't help themselves. And there is certainly some truth in that. After all, researchers are trained to see the wood for the trees full of data. How else does one get a grip on things? Then again, what we do in our daily lives is not so very different. It

is a habit ingrained in us by evolution. Upon entering a reception or party full of strangers, we subconsciously scan the crowd and make categories such as 'to be avoided', 'safe and likeable', 'drunk', 'boring', and so on. It is a mechanism that is rooted in our survival instinct. As a scientist, though, one has to be aware of the fact that as human beings we instinctively categorise everything. A scientist's goal, then, is to introduce an objective rationale to the groups one is creating. All the same, one has to keep in mind that the categories one devises for a certain experimental setup are man-made constructions; constructions that are only suitable for that particular context and may change over the course of time. The biological man/woman distinction is a binominal division of mankind based on chromosomes, which is absolutely valuable in a medical context. After all, women are highly unlikely to develop prostate problems. But for a researcher of gender identity this distinction is too limiting. As it is for people too. Every qualification only has a surplus value within the context of the predetermined research question. Distinctions are changeable depending on context, application, and so on. New insights will overturn systems of classification and/or adjust them.

All scientists use categories to bring order to chaos. Linguists are no exception. In the theme called 'Chaos' we present a word map for the entire Dutch

and Friesian language zone for the word 'vlinder', which means 'butterfly'. The data come from the *Reeks Nederlandse Dialectatlassen* (Series of Dutch Dialect Atlases) by Professor Edgard Blanquaert (1894–1964). The map shows the dialect words for 'coloured butterfly' and where these words are in use. But how does a dialectologist draw (choose?) the geographical borders between dialects? In dialectology, so-called isoglosses are determined based on pronunciation, because sound structures are much more stable than, for example, vocabularies. This makes it possible to draw a line between areas where people pronounce 'ik' ('I') as 'ik' and those where it is pronounced 'ich'. But which words to choose as criteria to define isoglosses and borderlines between dialects is the subject of much debate among researchers. The lines create categories that give linguists something to hold on to in their study of the origin and evolution of language, but the reality of language is much more complex. A border between two languages is, after all, more likely to be determined by politics and societal influences. The same goes for when to call a dialect a language.

DOUBT: Van Leeuwenhoek's microscope

In the theme 'Doubt' we explain the difference between observation and interpretation in scientific methodology. To 'see' something does not imply that you know what you are looking at. You make your own interpretation of it, which is also influenced by your frame of reference. This is inevitable, and only too human. This frame of reference is formed and influenced by your cultural context, education, experience, and so on. From this insight, that interpretation is always 'coloured', it follows that scientists should always doubt their interpretations, keep on doubting them, and open them up to debate among fellow scientists. It is the only way to create a system in which we attempt to filter out as many systematic errors in the interpretation of our observations as we can. Only this keeps science from becoming dogmatic.

Imagine you are the very first human to peer down the lens of a microscope. Never before you did anyone enter into and explore the world in miniature. Antoni van Leeuwenhoek (1632–1723) is considered to be the founding father of cell biology and microbiology. Yet he was not a trained scientist. He was a cloth merchant and used a magnifying glass to inspect the density and quality of textiles. His had a power of magnification of 3×. His unbridled curiosity and technical ingenuity in, among other skills, cutting lenses drove him to produce a lens

with a magnifying power of 270×. He excelled in minutely documenting everything he put under his lens. Later he would document his observations and conclusions in letters to the Royal Society in London. Browsing these letters and drawings is like making an amazing journey through the head of Peter Pan.

I can still clearly remember getting my first microscope, made by a well-known toy manufacturer. I will not mention the brand name, but it was one of those beautiful red ones. I remember how it opened up a whole world, introduced a new way of looking. The urge to place everything, and I mean everything, under the microscope was almost uncontrollable; preferably the weirdest things first. Today, it is my children's turn to inspect the most bizarre items under the microscope. They suddenly become little explorers, enthusiastically bringing one piece of dirt found on the floor after another to be examined under the microscope.

An almost identical, childlike urge to experiment can be traced in the letters Van Leeuwenhoek sent to the Royal Society. Anything that more or less intrigued him, he investigated with his microscope. There was no end to his inspiration. He was the very first person to see spermatozoids wriggle under a microscope. How bizarre must that have been? To see something move even before having the slightest notion of how procreation

works exactly. Staring into the unknown. Because then comes the next step. Seeing it is one thing, but it only becomes science when you attach an interpretation to it. Van Leeuwenhoek interpreted the spermatozoids as tiny swimming humans. His colleague and contemporary Nicolaas Hartsoeker would even draw homunculi, folded small humans, in the heads of sperm cells. He did admit that he never actually saw them, though. Anyway, in this hypothesis women appeared only as fertile receptacles. It was the prevailing notion of the time and it will have coloured what these gentlemen saw or thought they saw. Observing, interpreting, and having the courage to adjust your interpretation, regardless of ego – that is the fundamental underpinning of scientific thinking.

Being objective is crucial in science ... One has to be prepared to change one's views in the face of evidence, objective information. It is, however, an illusion that scientists are unemotional in their attachment to their scientific views. – Lewis Wolpert *(The Unnatural Nature of Science,* 1992)

The example of the spermatozoids is somewhat gratuitous, in the sense that it is not so difficult to accept that the interpretation needs to be adjusted a few centuries after the initial observation. However, this is an exercise

that never stops in science. At best, one hypothesis leads to a multitude of more sharply formulated questions, but never to a definitive answer. In addition, the questions are informed by a never-ending exchange between technical progress and the insights we gain from it. For example, we have only recently been able to functionally analyse our brain in activated regions. Using functional MRI we can produce beautiful colour maps of our brain. But when it comes to interpreting what information these colour patterns actually contain, we are still barely scratching the surface.

MODEL: reinforced glass beam

Scientists attempt to gain insight into reality, which is simply too complex to study as a whole. The phenomena that shaped the world and its inhabitants are a wonderful jumble of interacting processes. You can become obsessed by that jumble and completely lose your way in it. As a researcher you are looking for that one minuscule thread that will allow you to start unravelling the whole knot. For example, you can't just simply test and prove the theory of evolution in a laboratory. What you can do is work in a dissection room and find anatomical evidence that empirically supports the theory of evolution. Besides, there are too many factors that make reality variable and unpredictable. In addition, in the real world

these variables are uncontrollable. It is a realisation that is actually a nightmare when setting up experiments. It's like having to bake a cake without scales, in an oven with a flaky thermostat.

This is why scientists make models of – partial aspects of – reality to make it comprehensible, researchable, and even predictable. In a model some variable factors can be controlled. You develop an artificial construction for your experiment to flourish in a controlled manner, or at least have the illusion of control. Of course, as a scientist you mustn't lose sight of how to link back your conclusions drawn from that model to the complex reality. Apart from ethical restrictions, the reality of the human body as a direct object of study, for example, is a much too complex entity for medical scientists. Suppose you want to test a new chemical molecule for medicinal purposes. All bodies are genetically different, have been submitted to different environmental influences, and so on, which may influence the effect of this molecule on a particular body. Suppose you would administer the molecule to a randomly chosen group of test subjects with the idea of mapping its effects or side effects. Apart from the fact that the results will probably be all over the place – making it extremely difficult to draw any strict conclusions from them – how will you ever determine whether

the variation in response is caused by genetic diversity, or by a variation in diets, living environment, and so on?

This is why such research first takes place within the framework of a model, for example laboratory animals. Mice can be bred with a known genetic coding and can be held in the same circumstances, with the same diet and other variables kept fixed. Although the laboratory animal model is unfortunately still necessary, we are increasingly successful in using alternatives such as cell cultures, thereby decreasing the number of laboratory animals used. However, in translating the conclusions from the laboratory animal models to the original research question we always have to be very cautious. A mouse is, after all, a mouse, not a human being.

In the museum arrangement we display various types of models used by scientists, such as those used in education as simplified renderings. The anatomic model of the eye, for example, which we all know from the classroom, is not just a schematic, convenient representation of reality. It is also a scaled-up one, stripped of all the slimy, bloody, smelly and other potentially nauseating elements that are not particularly conducive to making students absorb information. Still, a link to reality is necessary here, or at least the notion that this cleaned-up version of reality is an illusion. Practising like mad on this model does not make one an ophthalmic surgeon.

Another example that we exhibit is a reinforced glass beam with a beautiful pattern of cracks from the Laboratory for Model Research of the Faculty of Engineering and Architecture. Glass is being used more and more often for load-bearing constructions in buildings, for example as glass floors, glass columns, or glass beams. Obviously, the constructional safety of such elements is of the utmost importance. In the laboratory, experiments are carried out to test how much load a glass beam can bear before it succumbs. This is accomplished by bringing a controlled bending force to bear on the beam and then mapping the cracks. The more tests are run, the more accurate the computer model becomes in predicting where the cracks will occur, in what pattern, and when the beam will finally break. When the computer model correctly predicts reality, it can be used to design safe glass load-bearing constructions 'in real life'.

MEASURING: Senufo twins figure

At first sight, 'Measuring' would traditionally be an unavoidable theme in a science museum. After all, the collections contain a large number of instruments of measurement. Moreover, accurate measuring is unconditionally linked to science. It would therefore seem a rather straightforward theme. To measure is to know, right? It seems self-evident that the search for the initial

hypothesis in starting a line of research is a real challenge. The subsequent questions of what to measure and how to measure it exactly are too.

Many things are simply not directly measurable. How, for example, do you measure climate change over a span of centuries? Researchers often use proxies: measurable data that indirectly tell us something about difficult to measure phenomena. Fossils of foraminifera – onecelled organisms with calcium skeletons – are an example of an often-used proxy. Some of them thrive better in a warm environment, others in a cold one. Foraminifera fossils that are found in certain strata can indirectly tell us something about the climate of the period when the stratum was formed. These foraminifera come with a bonus to museums: they are beautiful. Ernst Haeckel described them in his *Kunstformen der Natur* (1904). The lithographs by Adolph Glitsch that illustrate the book so beautifully today feature as reproductions of abstract artistic forms in numerous living rooms and teenagers' bedrooms. At the GUM we display the foraminifera in a series of nineteenth-century miniature plaster models.

What may thoroughly dampen the scientific party spirit is that not everything is, or has to be, measurable. No matter how many proxies we may find, the emotions and human norms and values that make the world so complex but also beautiful are hard to express

in numbers. Then again, these are exactly the things that we humans would so very much like to be able to quantify in order to make their quality tangible. How to measure love, for instance? In the West African Senufo culture twins have a special status. Both twins should receive the same amount of love. In order to distribute the love evenly between your children, you first have to make it measurable or constantly evaluate it. At the GUM we display a wooden figure of twins from a Senufo household. This sculpture serves to keep the mother permanently sensitive to the importance of treating and loving her twins equally.

Sometimes the right instrument to measure something is not, or not yet, available. Scientific collections are often a treasure trove of devices that demonstrate the ingenuity of the scientific brain in making the unmeasurable measurable. In the GUM display we showed the first commercially available electrocardiographic (ECG) device. It dates from 1918. It was already known that the beating of our hearts involved tiny electrical currents. However, the right equipment for measuring this electric activity on the body, let alone registering it for use in medical diagnostics, was not available. In 1901, Willem Einthoven (1860–1927) invented the string galvanometer. For the first time, using a very clever system, he was able to register the now well-known schematic representa-

tion of a heartbeat. In this measuring system the patient was obliged to have both hands and one foot in water to optimise conductivity.

In their enthusiasm for making connections, researchers are sometimes inclined to measure things that are simply not there. This goes against scientific thinking – measuring something in order to prove a proposition. One should of course follow the opposite reasoning: taking numerous measurements. And when these show a connection, one should present the most plausible explanation for this connection. But scientists are only human. Sometimes the urge to prove a proposition – and by association to prove that one is absolutely right – can be too strong. All the more so when some political or other motivation is creating fog in the background.

At the beginning of the nineteenth century, Franz Joseph Gall (1758–1828) introduced the theory of phrenology. The idea was that the development of certain parts of the brain ran parallel to certain character traits. These either more or less developed brain regions supposedly determined the shape of the surrounding skull, forming lumps and dents. Subsequently, the character and personality of the skull's owner could be derived from feeling the skull. Although this theory was never scientifically proven, it was used to lend credibility to all kinds of half-witted ideas. Cesare Lombroso (1835–1909), for

one, building on the theory, wanted to determine someone's propensity for criminal behaviour by studying their facial features. In his book *L'uomo delinquente* (1876) he describes the 'born criminal'. Criminality, according to him, was inherited and could be determined by looking at physical characteristics. The craniometer that we exhibit was originally used in the nineteenth century by hat makers to determine the shape of someone's skull but was later also used as a measuring instrument to underpin the theory of phrenology.

IMAGINATION: the brain arteries of a horse

Any idea of creativity in science – which is rare – is linked, romantically and falsely, with that of artistic creativity. – Lewis Wolpert (*The Unnatural Nature of Science*, 1992)

Creativity and imagination are crucial aspects of scientific work. I agree with Wolpert that this is a different kind of creativity from that in the arts. Every experiment you set up must be described like in a cookbook. Your colleagues, and those who come after you, must be able to follow your train of thought in every detail and be able to repeat your experiment in order to check its outcome. Such a dry, meticulous recipe may not look very creative,

but nothing could be further from the truth. The whole process leading up to the recipe requires a very flexible mind. All researchers first conceive of the cake they wish to bake and how to go about it. It is only after much failure, cursing, despair, and adjustment that they arrive – with a bit of luck – at something that is palatable. Writing down the various steps towards that edible cake is not something most researchers – at least not the ones that I know – are very passionate about. On the other hand, they are passionate about free thinking, messing about, and tinkering.

> The cry of *'Eureka!'* may be rarer than popularly supposed, but, even so, the cry does ring out over the centuries. But the cry is often misleading, for it suggests that the solution to a scientific problem comes in a moment of divine, or ablutional, inspiration; it neglects the slow and often painful process from the formulation of the problem, through false turns, to that lovely moment of solution. – Lewis Wolpert *(The Unnatural Nature of Science,* 1992)

After a lengthy but rewarding quest for the thread in the knot, my PhD research in anatomy would eventually turn to a system of blood vessels in the omentum of the dog. The omentum is a part of the peritoneum. It is pres-

ent in all mammals and is draped like an apron between the abdominal wall and the intestines. It is attached to the stomach but for the most part hangs loosely in the belly where it sways along with the peristaltic motion of the intestines. Its function long remained unknown and was the subject of much guessing. The Romans thought that it warmed the organs inside the belly, because a gladiator who lost part of his omentum after suffering a stab wound felt cold for the rest of his life. On the basis of observations, it gradually became clear that the organ had a protective and healing function. Via its blood vessels it supplies various components to the abdomen and its organs, enhancing the healing of wounds and the formation of new blood vessels. By the end of the twentieth century it acquired an almost magical-mysterious status. Probably not completely by coincidence my attention was drawn to it.

These healing capacities make it an interesting organ for surgeons to work with. After major surgery on the intestines they stimulate the healing process by simply draping it across the afflicted region. In order for surgeons to be able to manipulate the omentum in more complicated procedures, they should be thoroughly acquainted with the blood vessel patterns. I studied the omentum and its blood vessels in dogs as a surgical method for dogs as patients and as a model for

humans. However, documenting blood vessel patterns in an organ as flexible as the omentum is not easy. In the end, it took many hours of joyous tinkering with latex and foam sealant (I will spare you the details) in the dissection room to arrive at a reproducible research model. Curses, sighs, and frustration, but also continuously challenging oneself to come up with alternatives for a quest that is totally absorbing. And then to experience the blissful feeling when all the pieces of the puzzle fall into place. Once I had arrived at the solution, however, the fun ended – at least for me. The quest itself had been the real joy. Is this about artistic creativity? No, far from it. Is it about creativity in the sense of the ability to create something new? I dare say it is. And there is at least a little bit of imagination involved. Call it curiosity, the urge to experiment, wonder, or whatever. Let's not try to define exactly what motivates 'homo ludens'. One thing is sure: he or she hides in every scientist and artist.

Of course, I wasn't the first to undertake an exploration in order to map blood vessels through dissection. Dissecting implies cutting (i.e. a destructive process) and therefore implies a cadaver, which is perishable by definition. It is a quest to create a three-dimensional and durable study model of the system of blood vessels. Leonardo da Vinci (1452–1519) was the first to come up with a solution. He injected liquid beeswax into body

cavities, let it solidify and then dissected the replica. Over the course of the centuries after Da Vinci, numerous anatomists have looked for alternative materials to use as injectable fluids. Among the better-known are the Frenchman Honoré Fragonard (1732–1799) and D. H. Tompsett (1910–1991) from Britain. The latter was the first to make casts in plastic. At the GUM, a cast of a horse's brain arteries illustrates this centuries-long ingenuity of anatomical researchers.

KNOWLEDGE: Egyptian canopic jars

> some [observers] have found the nature of science puzzling, and some have even come to doubt whether science is, after all, a special and privileged form of knowledge – 'privileged' in that it provides the most reliable means of understanding how the world works ... The whole history of science is filled with new discoveries and the overthrow or modifications of ideas which were held to be true. So in what sense, then, is scientific knowledge a true description of the world, and what right have we to call it 'privileged'? – Lewis Wolpert (*The Unnatural Nature of Science*, 1992)

The goal of science is the development of knowledge, that much is clear. Science is a human construct that

creates objective knowledge against our intuitive thinking. It must always be open to adjustment and criticism. This anti-dogmatic stance is safeguarded by the scientific community itself. This does not imply that science is the only form of knowledge development, let alone that it is the only way for us to look at life, to live life. It is not privileged knowledge, but a form of knowledge beside other phenomena that inform and colour our powers of the mind. Artistic research, for example, creates knowledge just as well, albeit with a different goal than generating objective, reliable knowledge. All the same, its impact on society can take root as broadly and as deeply. One can hardly deny the significance of artists such as Louise Bourgeois or Frida Kahlo for feminism or how they helped shape the view of humanity in the twentieth century.

Art fine-tunes the knowledge, values, and norms of a society and in addition it has the power to touch the individual mind. Science has little time for the individual or the anecdotal. In drawing conclusions, scientists will always try to generalise findings. An insight about a single cell is not relevant, but what that same insight may mean for a whole group of cells, for tissues, and organs definitely is. The scope of art is to be less restrictive. Art can and may have an impact on both the individual and the group. Personally, I was once almost moved to tears by a work by

Anselm Kiefer (*Lilith am Roten Meer/Lilith at the Red Sea*, 1991) at the Hamburger Bahnhof Museum in Berlin. This viewing experience promptly displaced me from my surroundings and from the here and now. It wasn't the first, and most likely won't be the last, time that art triggered in me a mode of contemplation. These are experiences that enrich self-knowledge, at least for me.

We sometimes tend to forget how recently scientific thinking was introduced in human history. Knowledge could and still can be gained through experience and practice. In the GUM exhibition we display Egyptian canopic jars, grave vases in which the intestines of the deceased were kept after mummification. In ancient Egypt it was believed that after death one would live on in the underworld. Therefore, the body and organs had to be preserved. The religious practice of mummification thus indirectly produced accurate knowledge of the human body.

In order to disseminate knowledge across borders and generations it first has to be laid down. In our museum display we show a variety of knowledge media, media for knowledge transfer, and the evolution they went through. The invention of printing would lead to an explosion in the spreading of knowledge. What digital culture and robotics may mean for education today is a growing scientific research discipline. In the academ-

ic world publications are the default format, with peer-reviewed journals as the platform. Unlike the written word, models and scale models serve as three-dimensional knowledge media that can enhance the learning process as hands-on tools. An even stronger medium to convey messages to our brains are stories. To illustrate this, we have a *wayang revolusipop* that was used in the Indonesian culture of shadow puppet play. This specific puppet was used between 1947 and 1949, during Indonesia's War of Independence. In a time when media such as radio (let alone television) were not yet common, the popular *wayang kulit* puppet play was *the* means to bring the message of the revolution to large numbers of people. The Indonesian nationalists used the theatre art form of *wayang* as a propaganda tool in their fight against the Netherlands.

NETWORK: Burggraeve's head

Another crucial difference [between science and] common-sense or lay theories is that scientific theories involve a continual interplay with other scientists and previously acquired knowledge for scientific ideas are directed not just at a particular phenomenon in everyday life but at finding a common explanation for all the relevant phenomena, and an explanation which other

scientists would accept. – Lewis Wolpert *(The Unnatural Nature of Science,* 1992)

Science is not a solo enterprise. The network of knowledge creators is an essential cog in the engine of knowledge creation by science. This is so for various reasons. As mentioned earlier, safeguarding anti-dogmatism is crucial for the scientific process. This can only be done when the propositions put forward by scientists are always available for scrutiny by a network that primarily consists of their peers. The formation of that web of peers implies an inclusive process. If certain expert minds were to be excluded from taking part on the basis of bias, this would obviously lead to poorer knowledge. We have to be honest: the academic-scientific network does not have a great track record in this respect. For one thing, with the rest of society it shares the delusion that the voices of women can be safely ignored. That is no less than fifty per cent of global brain capacity, mind you. In the early twentieth century, Bertha De Vriese (1877–1958) was the first woman medical doctor to graduate from Ghent University. She was a brilliant researcher in brain anatomy. Her work is still being cited and the study objects she created for her doctoral research are exhibited as examples of ingenuity at the GUM. Eventually, she would hit the glass ceiling and was forced to continue her ca-

reer in a private practice in Ghent, as the son of the then Professor of Anatomy was his designated successor. A classic case of nepotism and patriarchal power display.

That's just the way it was in the early 1900s. Of course, we have left all that behind us and it is no longer a problem. Or is it? I would be lying if I were to claim here that the academic and scientific institutions of today have been cured of this plague. Strange, how digging in my own experiences leads me to conclude that gender inequality in the academic world, and far beyond, has not been eradicated at all. The unequal treatment may not be as openly and flagrantly evident as a hundred years ago. Today, it plays out in more subtle, less explicit, and less conscious ways. Take, for instance, my choice to study veterinary medicine, which was met with some derision. Vets were (sorry, are) still associated with men stomping through barns in rubber boots. Caring for household pets was just about acceptable for those called by some – i.e. the faculty chairman at the time – 'the pussy girls'. Chihuahuas, not cows and horses, as the latter's size was not 'woman-friendly'.

The fact that I would eventually do my PhD research in anatomy and in the process would dissect whales still feels like David's victory over Goliath. The functioning of the scientific enterprise is therefore better off if it is protected by a broader network than one consisting

exclusively of peers. A brilliant expert in one discipline does not necessarily make a good manager. The need to build in control mechanisms may seem logical, but is not always self-evident. Sharing knowledge and thereby opening it up to criticism requires transcending the human ego. Not exactly an easy task for the species that calls itself 'humans' and has succeeded in appropriating its own era. In 1837, the Ghent anatomist Adolphe Burggraeve (1806–1902) presented his specimen of 'woman with neck and hand' to the public. Those who saw it were wildly excited by the semblance of life that was captured in the specimen. It was as if at any moment she would open her eyes and rise to the surface of her glass jar with a sigh, to gulp some air. Aesthetics were seen as important in anatomy education. Processes of decay and other natural wonders that necessitated distance were thus circumvented, leading to less trepidation among students and a wider audience to study his specimen more closely. Burggraeve's specimens have a macabre beauty and have undeniably contributed to the democratisation of anatomy education.

His conservation technique was both excellent and fascinating. Burggraeve has not been with us for quite some time, but two hundred years later at the GUM we present his specimen of the woman who so beautifully and immutably withstood the ravages of time. His suc-

cess elevated the anatomist to a different, almost star-like status. Still – quite at odds with the rules of science – for a long time he kept his techniques for dissecting and preparing a secret. It was a sort of game in which by creating magic and mystery the expertise of the researcher was hidden behind a veil. If Watson and Crick had applied the same secrecy about their discovery of the structure of DNA, we still would not be cloning today.

Sharing and discussing insights is of course only possible if we understand each other. Due to the ever-increasing specialisation in science, there is a risk that scientists from different sub-disciplines no longer understand each other, simply because they speak a different 'language'. A concomitant problem is that the network of peers around them shrinks accordingly. If only a handful of people are able to grasp what you're doing, then the control mechanism becomes less efficient. And the chance that from a smaller, mutually confirming pool of minds an out-of-the-box idea suddenly pops up grows slimmer. Professor Lieve Van Hoof conducted network analyses based on correspondence in the Roman Empire. In the GUM she introduces the theme of 'Network'. She pointed out to me the concept of 'the strength of weak ties'; if you only keep fishing in your own little pond of contacts, the chance of having innovative ideas decreases over time. After all, it is primarily

the like-minded who will be swimming in that pond. It is important to find bridging figures who may be outside of your comfort zone but who can bring you into contact with other ponds, with other views. Someone with whom you have a weak link may potentially lead you to more new ideas than someone from your own trusted network.

The strength of weak ties. May the GUM flourish as a meeting zone for weak ties!

The exhibition concludes with a film by, again, Sarah. As a final theme to illustrate the interaction of science and society we wanted to discuss borders. Borders, in the literal sense as something that is crossed when things become pseudo-science, but also the ethical boundaries of knowledge production and dissemination. Initially, as with the other themes, we went looking for objects with the right story to illustrate the theme fittingly. However, telling a story about the future using objects that by definition are in retirement proved to be a challenge, if not impossible, even if we had informed the whole display with material from contemporary research. We had clearly chosen not to be a museum about science history. But even objects from today would, after a few years in a museum context, become dated, more like a science fiction movie from the past than a futuristic image. How to visualise the future that has not yet arrived?

Sarah proposed to let scientists, artists, and children make predictions about the future, thus following the centuries-old custom of reading the future from animal organs.

Omentum Omentum became a cinematic installation about an experiment in *mantikē*, or divination. In this experiment, the participants were invited to read the blood vessels in this fascinating organ as a future-predicting pattern. As with an oracle, we seek their advice about what direction the production of knowledge is steering society in. Sarah sees the question as an invitation to envision the future out loud and freely. She compares it to how the French anthropologist-filmmaker Jean Rouch described his film practice (between fact and fiction) as: 'une injection du possible en réel' (an injection of the possible into reality). So, no traditional interviews, but a new way of having a discussion that may lead to new ways of thinking, and documenting these by filming. So, after an introduction in scientific thinking and scientific methodology, we conclude with an exercise in free association. Because the power of imagination can just as well lead to wisdom and, especially, beauty.

To conclude

An exhibition doesn't necessarily have to be a purely objective reflection of data. Curators may inject a narrative into the display. That narrative may have a certain, perhaps even personal, perspective on reality. As long as one makes the visitors aware that the exhibition is a view and not the absolute truth, this seems to me an absolute surplus value. In this way a curator explores the medium of exhibitions to the full to tell the story in all dimensions, including experience, and looks for a personal bond with the visitor. It opens the door to more engagement and confirms the museum as a house for contemplation. I use the word 'curator' deliberately. In science museums, one is often called 'a member of the scientific staff' when selecting the content of an exhibition and flavouring it. But that term in itself is already limiting, as if you are bound to the blueprint of a peer-reviewed paper for shaping your exhibition. Why not let the personal and universally binding seep in? Not in scientific research itself, but certainly in its exchange with society.

FOR INSPIRATION

Kahneman, Daniel (2011) *Thinking Fast and Slow*
 London: Allen Lane
Pamuk, Orhan (2009) *The Museum of Innocence.*
 New York: Alfred A. Knopf
Wolpert, Lewis (1992) *The Unnatural Nature of Science.*
 Cambridge: Harvard University Press

Mural by ROA (photo: Michiel Devijver)

GUM – GHENT UNIVERSITY MUSEUM – A FORUM FOR SCIENCE, DOUBT & ART

GUM, located at the heart of the Ghent Botanical Garden, is a museum dedicated to science, research and critical thinking, where visitors can discover that scholarship is the result of trial and error, doubt and imagination. At the GUM, the visitor picks the brain of scientists. Which challenges do they face? How do they go about things? Is there room left for imagination, doubt and failure? How does that impact every aspect of our lives and way of thinking? And last but not least, which remarkable objects can illuminate this story?

ABOUT THE 'CHARACTERS' SERIES

Theater aan Zee and Studium Generale of HoGent present *Characters:* stimulating literary material in a small format, published four times a year. *Characters* are personal texts about a societal issue that evokes reflection, discussion, or debate. The authors are Dutch-language thinkers from various disciplines who express their outspoken opinions with a sharp pen in the form of an essay, a short story, or a word performance.